STOCKPORT

HISTORY TOUR

First published 2020

Amberley Publishing
The Hill, Stroud,
Gloucestershire, GL5 4EP
www.amberley-books.com

Copyright © Coral Dranfield, 2020
Map contains Ordnance Survey data
© Crown copyright and database
right [2020]

ISBN 978 1 3981 0171 5 (print)
ISBN 978 1 3981 0172 2 (ebook)

British Library Cataloguing in
Publication Data.
A catalogue record for this book is
available from the British Library.

Origination by Amberley Publishing.
Printed in Great Britain.

INTRODUCTION

Stockport is often thought of as an industrial town full of smoking chimneys and mills. In the nineteenth century this was the case, but the origin of Stockport goes back even before the Norman invasion of 1066 and possibly into prehistory.

The name is thought to be of Anglo-Saxon origin, with 'Stock' being a hamlet and 'port' being a marketplace. Stockport grew over centuries to be a major market town, producing cloth, hats and rope, with the spinning of cotton coming later.

The rivers Goyt, Tame and Mersey, as well as the Tin Brook and the many springs, have always played a part in the town's development by giving a protective barrier from the north as well as supplying water for waterwheels and industrial processes in the mills.

Today Stockport reflects all the aspects of its past lives, although in many cases the evidence is well hidden, but the street plan around the market and Underbanks is still as it would have been in medieval times.

This book and its tour around the Stockport of today endeavours to highlight some of these past lives and their importance to the town in the twenty-first century.

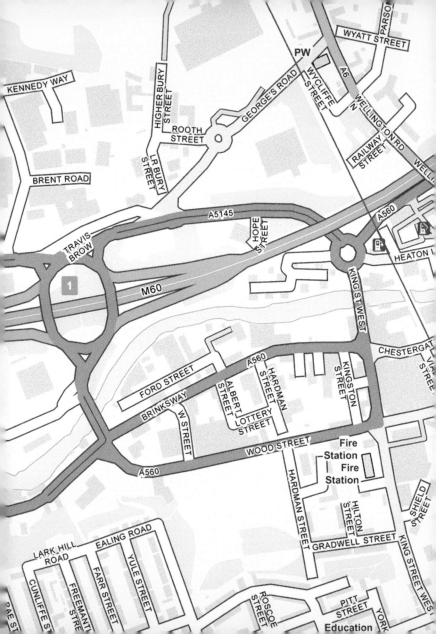

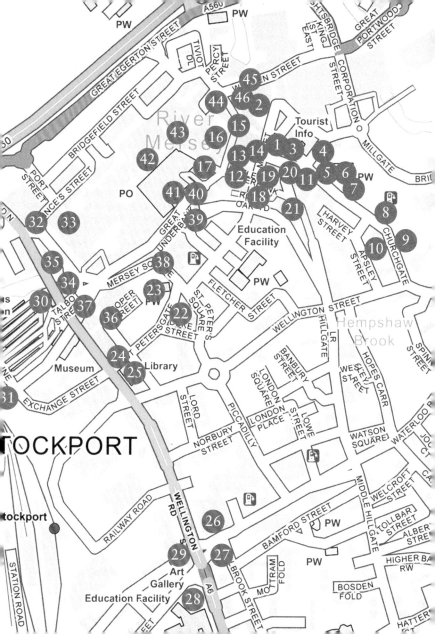

KEY

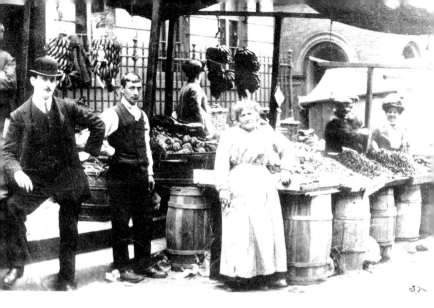

1. STOCKPORT MARKET

A market has been held on this site for nearly 800 years and probably dates back to the Anglo-Saxons, as Stockport is thought to be a Saxon name. It was an open space in 1260 when it was awarded a market charter. It had always bustled with the sound of shoppers, but today there are no outside stalls similar to the one in the photograph, only inside stallholders.

2. CASTLE YARD

Stockport was once a strategic crossing place of the River Mersey and a castle was built on a promontory of rock overlooking the ford in order to protect and guard the crossing. Built by the end of the twelfth century, probably of wood, it was later rebuilt in stone. After finally being removed to make way for a cotton mill, Castle Yard later became part of the cattle market.

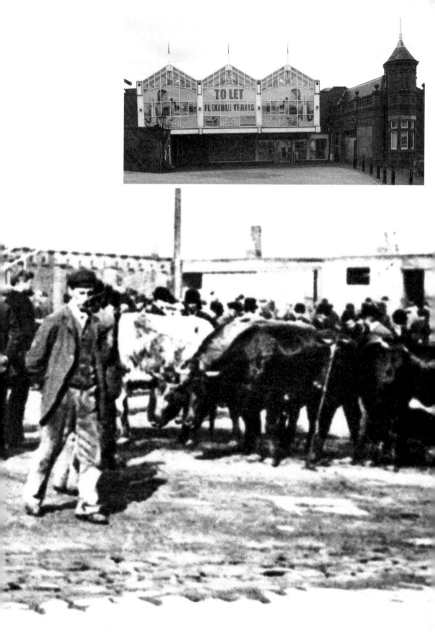

3. THE GLASS UMBRELLA

The large glass market hall that stands so prominently in the centre of the Market Place was christened the 'Glass Umbrella' as it originally had open sides, as shown in the picture. However, an enterprising stallholder requested to be allowed to box in his area to keep out the draught. He was Ephraim Marks, the younger brother of Michael Marks of Marks & Spencer. Others followed his lead until all the sides were closed in as today.

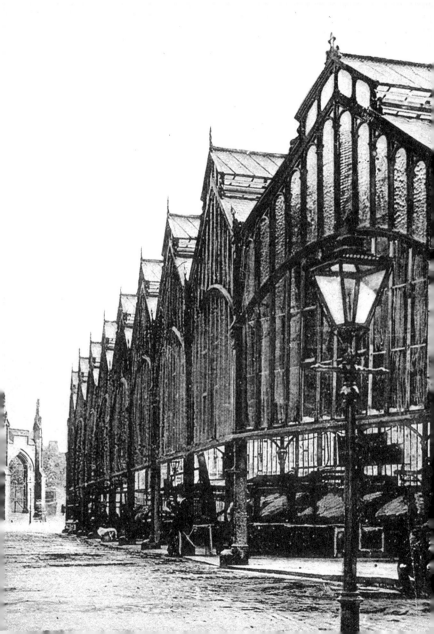

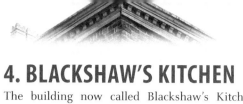

4. BLACKSHAW'S KITCHEN

The building now called Blackshaw's Kitchen was once a very popular pet shop, where small puppies could be seen cowering in the back of the window while eager children crowded around and dreamt of taking one home. When the building became unsafe its renovation was completed by incorporating windows that had been saved from an old baker's shop on Hillgate called Blackshaw's. The transformation was amazing.

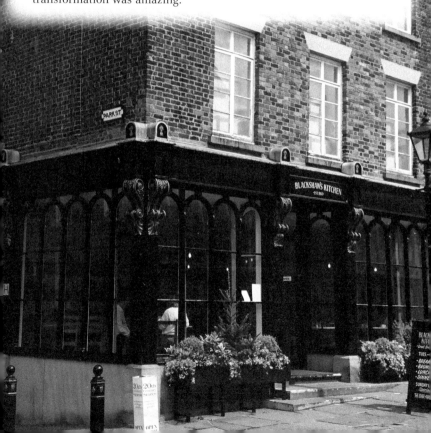

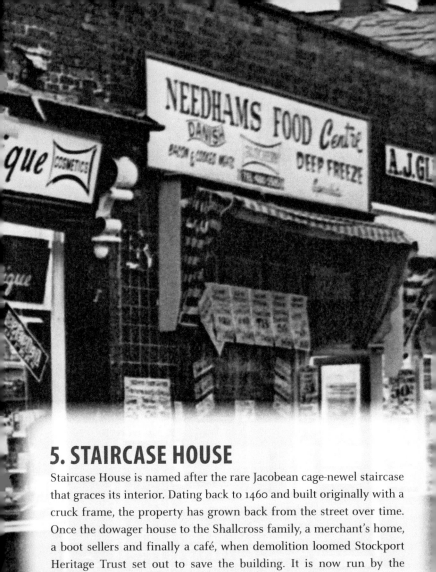

5. STAIRCASE HOUSE

Staircase House is named after the rare Jacobean cage-newel staircase that graces its interior. Dating back to 1460 and built originally with a cruck frame, the property has grown back from the street over time. Once the dowager house to the Shallcross family, a merchant's home, a boot sellers and finally a café, when demolition loomed Stockport Heritage Trust set out to save the building. It is now run by the council as a museum.

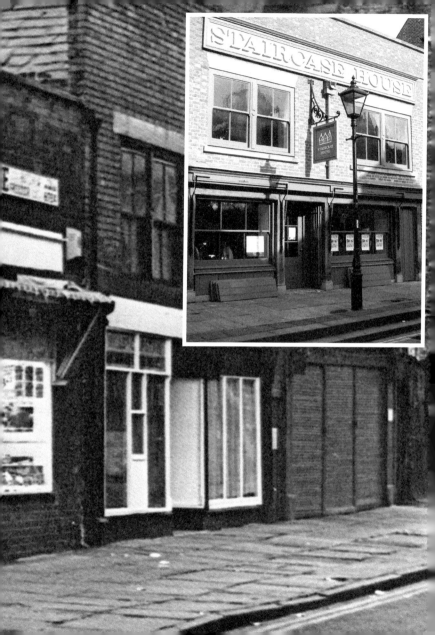

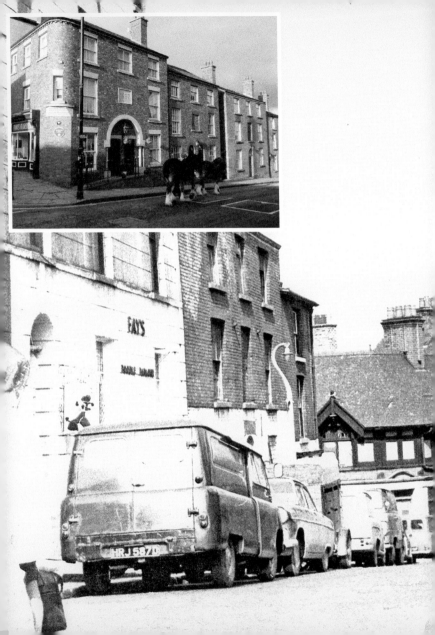

6. MILLGATE

Millgate is a medieval road leading down to the town's first corn mill. The Old Norse word for road was 'gate', and Stockport has many such roads, as in the eighth and ninth centuries the Vikings lived just across the River Mersey. Millgate in the nineteenth century had five inns down its length because of its proximity to the Market Place.

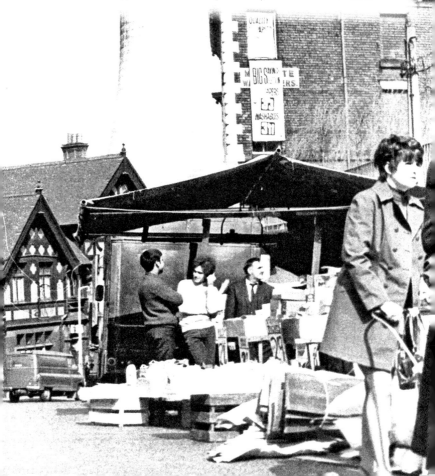

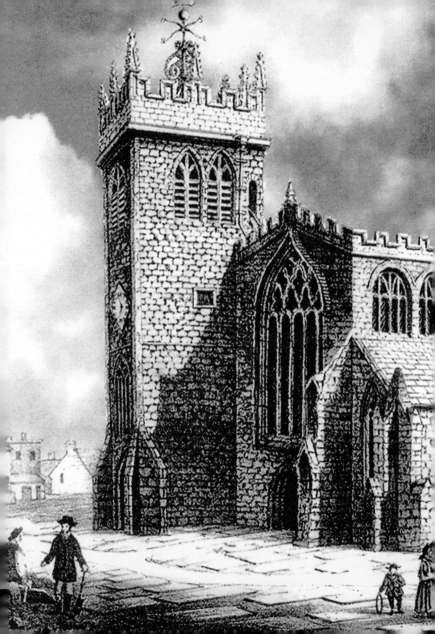

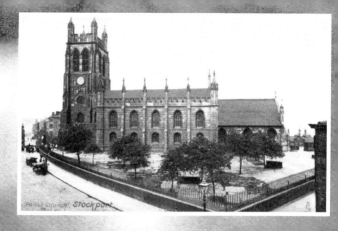

Parish Church. Stockport

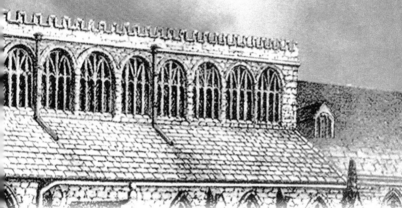

7. ST MARY'S

This stone church of St Mary's was built in the early 1300s but was not the first church on this site, as 'Matthew' is named as the first cleric of Stockport in the late 1100s. In 1810 a terrible accident in Liverpool, when a steeple collapsed and killed many children, caused churches all over the country to check their structures. St Mary's was rebuilt but the original chancel at the back remains.

8. LOYALTY PLACE

While this may be a seemingly insignificant road, it still sports an original pebbled surface, which is probably hundreds of years old. Once the home of John Lloyd, the town clerk, and James Birch, the constable, it was witness to an attempted murder when a crowd gathered after the arrest of a popular political agitator and demanded his release. Constable Birch was shot in the chest, but he survived. The bullet was found lodged in his breastbone after he died.

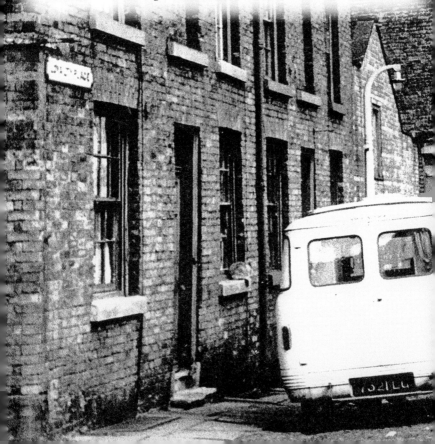

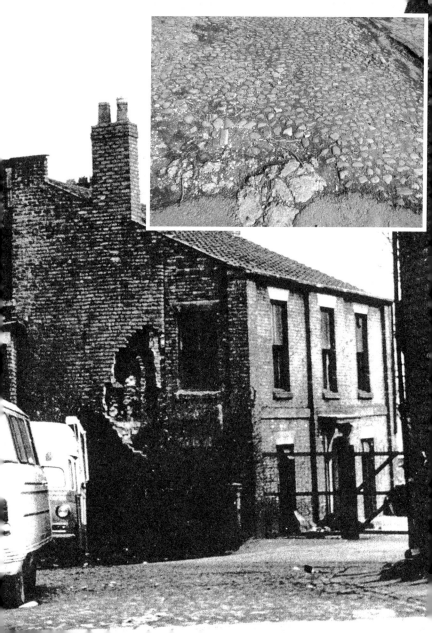

9. CHURCHGATE

This is another ancient road leading from the Market Place. The old shop in this picture still has a wattle-and-daub upper floor and the Old Rectory on the hill looks down over the town. It was once occupied by two generations of the Prescott family, with both father and son living to a ripe old age. As well as rectors of the church they were also magistrates, who were frequently called upon to read the Riot Act.

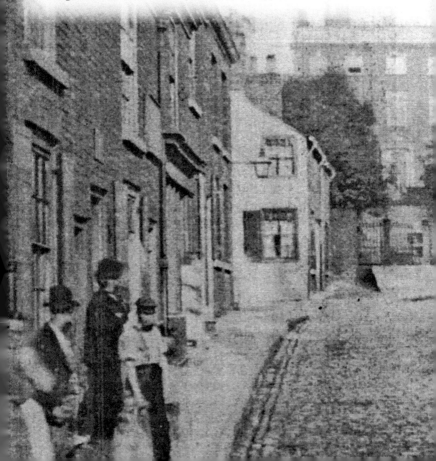

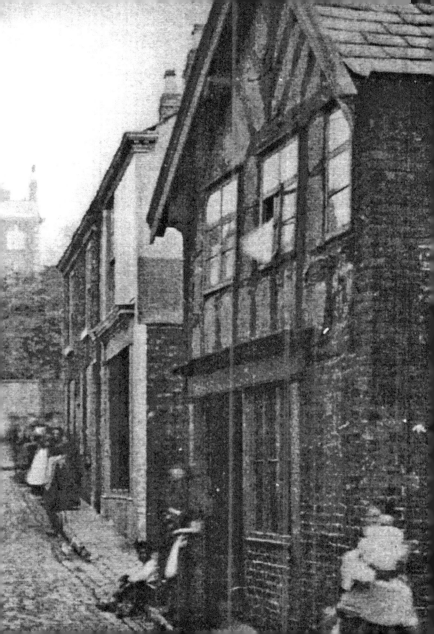

10. THE THATCHED HOUSE

This was once a thatched cottage tavern where a young Dr James Briscall took a room in the basement and began dispensing medicines to the poor and sick of Stockport. This grew until a new dispensary was built in Daw Bank and eventually this too was transferred to Stockport Infirmary in 1833. Seen here without its thatch, for many years it was a public house but has now been turned into flats.

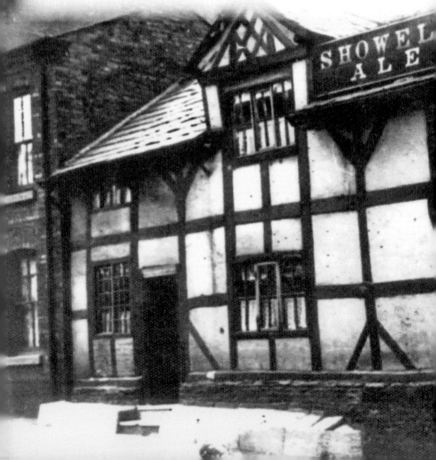

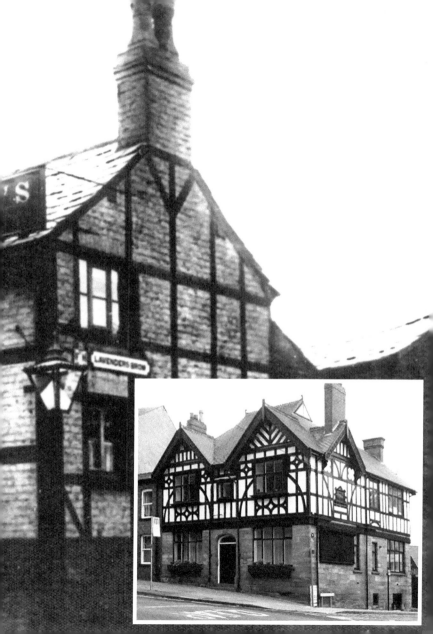

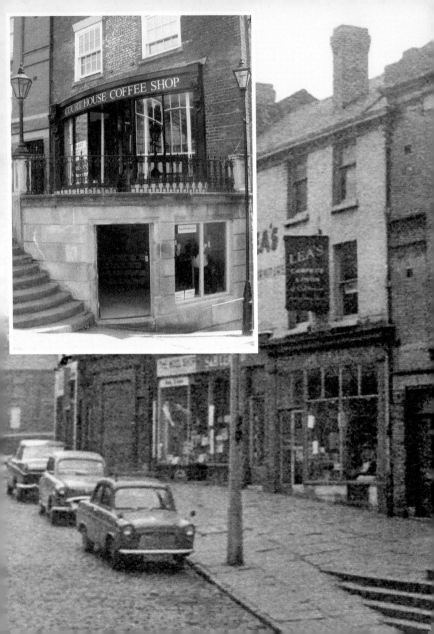

11. STOCKPORT DUNGEON

Used as the town lock-up, this small room with cells below housed the villains of the town. Minor offences were judged by the court leet, but murder or rebellions were sent to the Chester assizes. One such was John Dean, who in 1790 beat his pregnant wife until she was dead. He was held in the dungeon, then hung at Chester and returned to Stockport to be gibbeted for all to see on Great Moor.

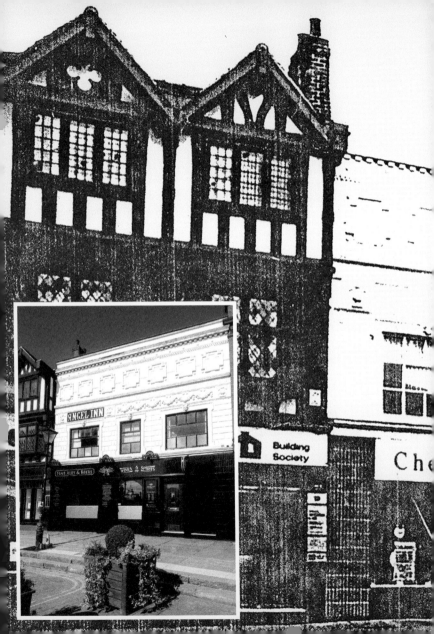

ANGEL INN

FINE ALES & BEERS WINES & SPIRITS

Building
Society

Che

12. THE ANGEL INN

This old market inn hides a fifteenth-century wooden frame. The room at the back, which was accessed from the yard, was once a concert room, but as the yard was where the prostitutes loitered it was probably not a respectable establishment. Later licensed as a theatre, it could be the first in Stockport. The Angel Gabriel heads and a new cement frontage were added in 1886.

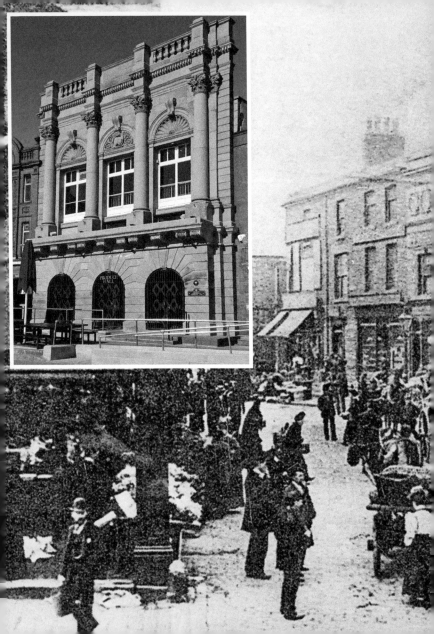

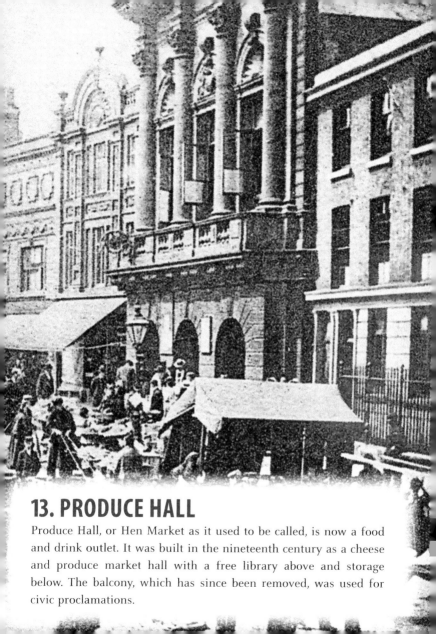

13. PRODUCE HALL

Produce Hall, or Hen Market as it used to be called, is now a food and drink outlet. It was built in the nineteenth century as a cheese and produce market hall with a free library above and storage below. The balcony, which has since been removed, was used for civic proclamations.

14. BRIDGE STREET

Bridge Street was built as a new road into the Market Place at the end of the thirteenth century to coincide with the building of Stockport's first bridge. In this photograph the hustle and bustle of life is plain to see. The fish shop to the left of the picture has been selling fish since the 1830s, and is still selling it today.

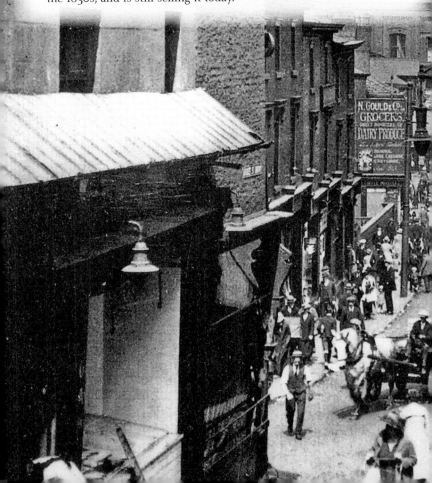

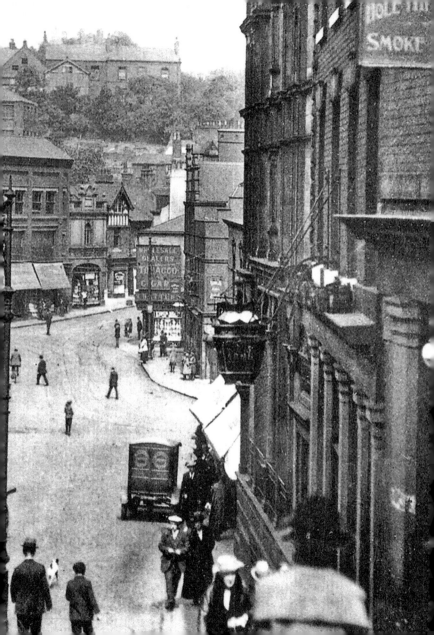

15. BRIDGE STREET BROW

This steep brow has had many names over the years: Kelso Bank, Brierley Brow and now Bridge Street Brow. It was built to match the dimensions of the bridge, which was 10 feet wide and, although the road has been widened, the top still measures 10 feet across. The number of people using the brow has dropped considerably as there are now easier ways to get to the market.

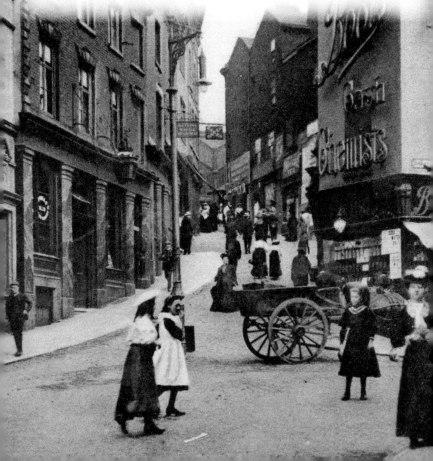

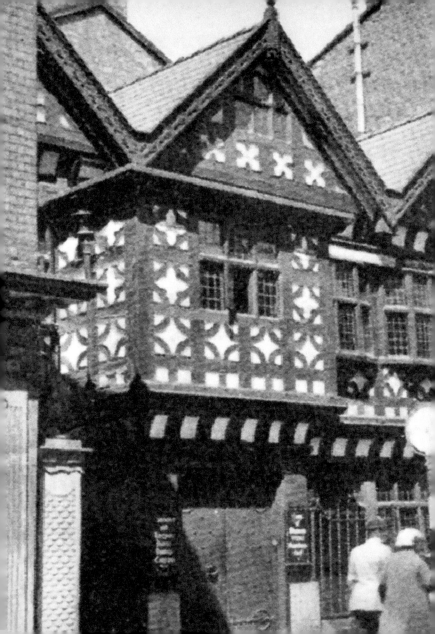

16. UNDERBANK HALL

Now a banking hall lined with elegant wood panelling and an impressive fire surround, the hall was built for the Arden family as a house where they could stay when doing business in the town. It was sold to John Winterbottam, an eminent man who founded the Stockport and Cheshire Bank in 1824. His story ended in transportation to Tasmania as a fraudster, embezzler and bankrupt. He survived and died a free man at seventy-eight.

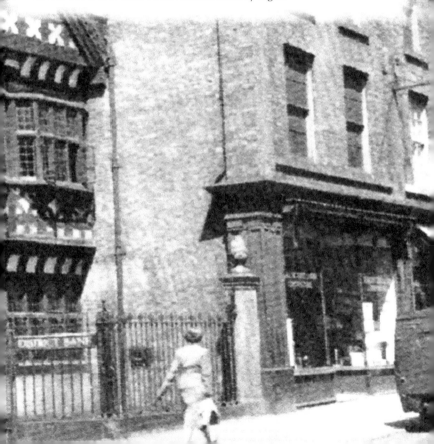

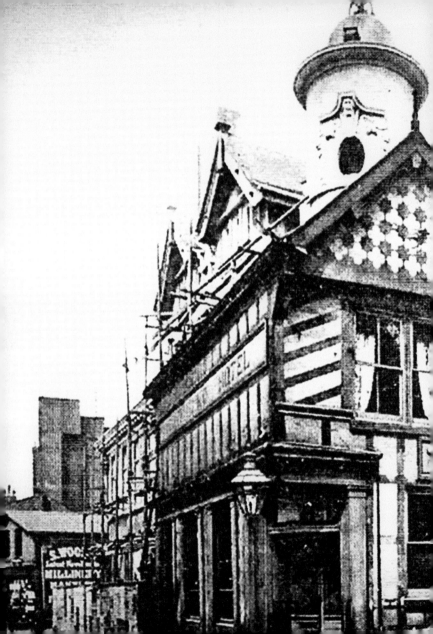

17. THE WHITE LION

The White Lion dates back to at least the fifteenth century. It was rebuilt in 1743 and again in 1904. The new building can be seen being erected behind the old in this image – doing this meant the license could be continued. Travellers could borrow fishing rods (the river was at the bottom of the garden) and a pew was reserved for them in St Mary's Church. There was stabling for twenty-two horses, and one was always kept ready.

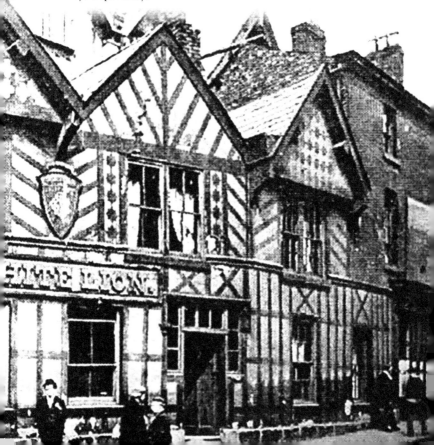

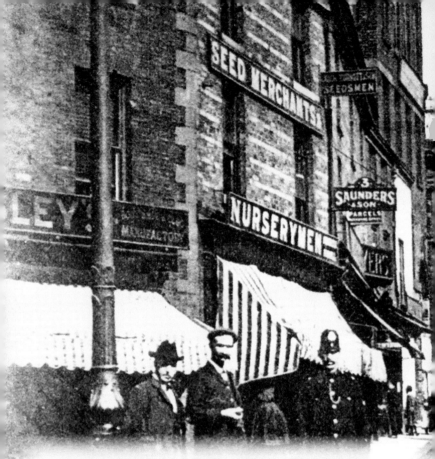

18. PETERSGATE BRIDGE

Petersgate Bridge was opened in 1868 to connect the west side of the growing town directly to the Market Place. It traverses the valley of the Tin Book and was one of a number of ideas put forward at the time to bridge the gap. The building of the bridge cut through the Queen's Head public house on Little Underbank and left it one third of its original size.

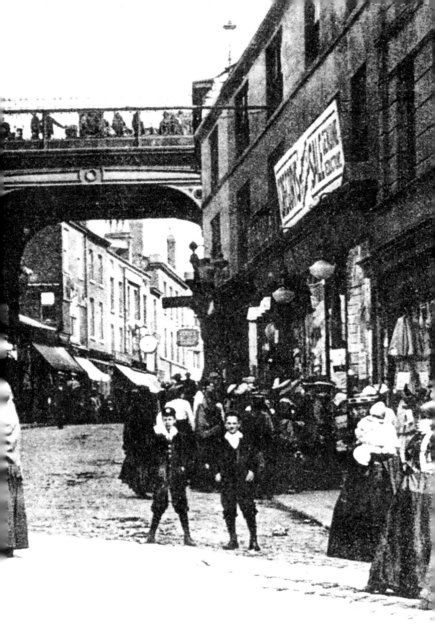

19. WINTER'S CLOCK

One of Stockport's most famous landmarks is Winter's automaton clock. It was installed by Jacob Winter as part of the frontage for his jeweller's shop. The three figures – a solder, a sailor and Father Time – used to sound the hour, half and quarters by ringing their bells. The figures have been repaired a number of times and in the inset a policeman watches the soldier as he is lowered to the ground.

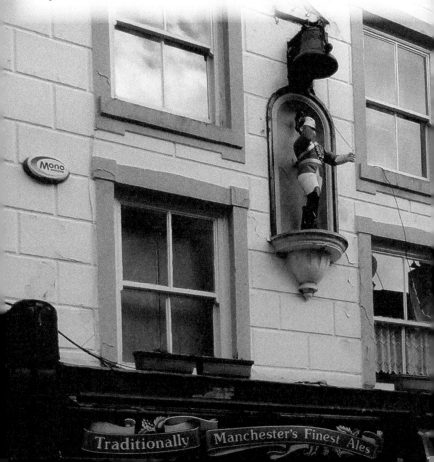

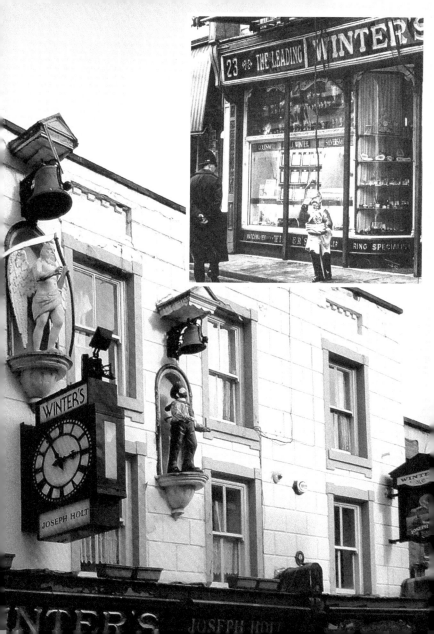

23 ✦ THE LEADING WINTER'S

GOLDSMITH J. WINTER SILVERSMITH

WINTER'S

RING SPECIALI...

WINTER'S

JOSEPH HOLT

NTER'S JOSEPH HOLT

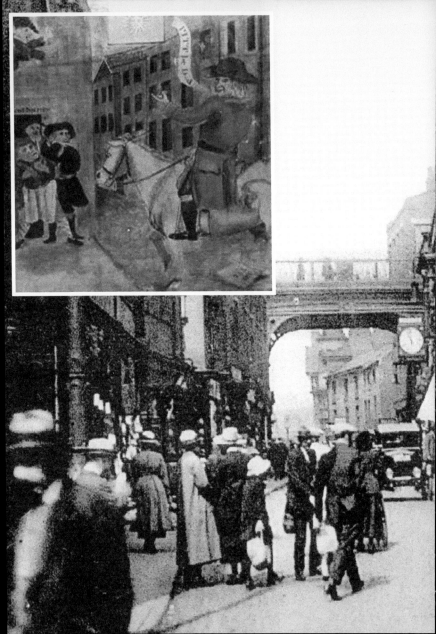

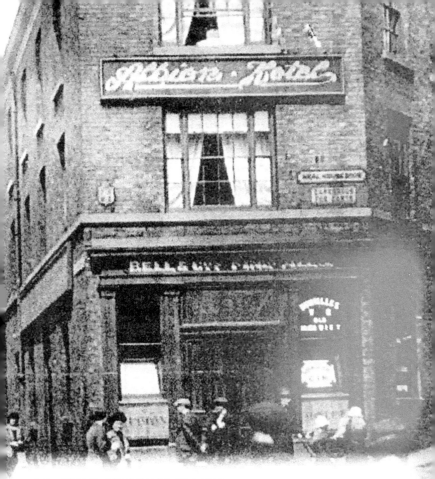

20. THE ALBION HOTEL

This large Georgian hotel replaced the very old Rising Sun Inn, made famous by Jonathon Thatcher in 1784 when he defied the prime minister of the day, William Pitt the Younger, by refusing to pay a tax on a saddled horse and rode to market on his cow instead. A local artist recorded the event in this pamphlet.

21. HILLGATE

For many decades Hillgate was the main road from Manchester to London. A continuation of Great and Little Underbanks, it joins what is now the A6. There were over 100 inns, taverns and beerhouses along its length in Victorian times, some of which were staging posts or goods depos and others were private houses. Unable to cope with the amount of horse-drawn traffic, a new bypass was built in 1826.

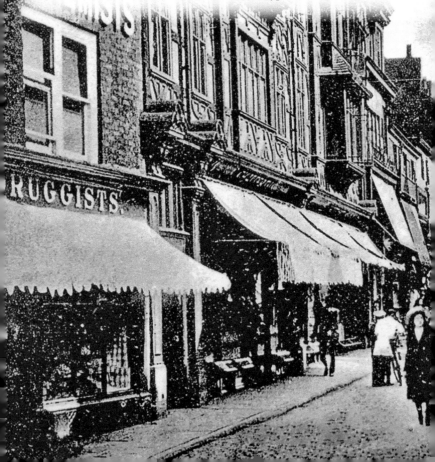

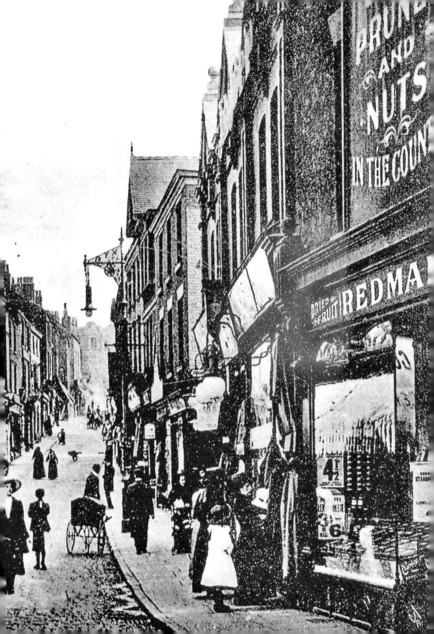

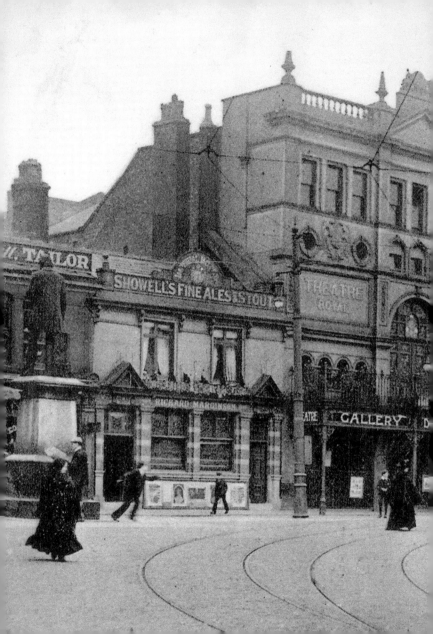

22. THEATRE ROYAL

Stockport's premier theatre was built in 1869, but after nearly twenty years a stove for heating caused a fire that all but destroyed the building. It was rebuilt in this impressive style in 1888. It saw the likes of Hylda Baker, Gracie Fields and Harry Lauder to name just three, but the rise of cinema caused a drop in theatregoers and, after resorting to coarse acts, the theatre closed.

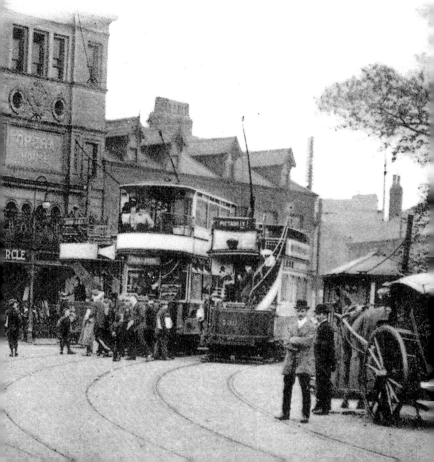

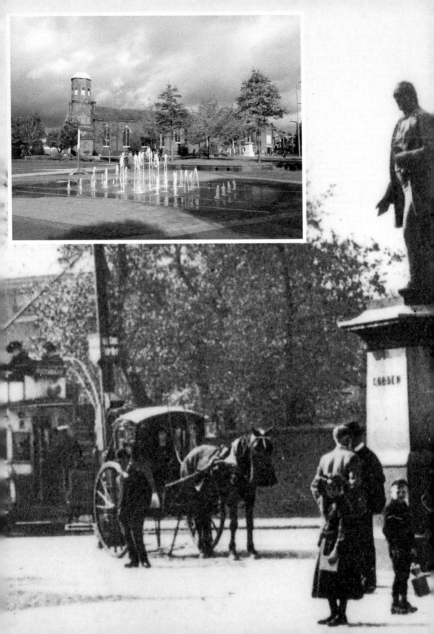

23. RICHARD COBDEN

In 1841 Richard Cobden entered Parliament as an MP for Stockport. Thus began his campaign to abolish the Corn Laws, which protected landowners' interests by levying taxes on imported wheat but as a result raised the price of bread, making it unaffordable for many poor families and caused starvation and rioting in the town. The laws were at last abolished in 1846 and a statue was put up in his honour in 1886 – twenty years after his death.

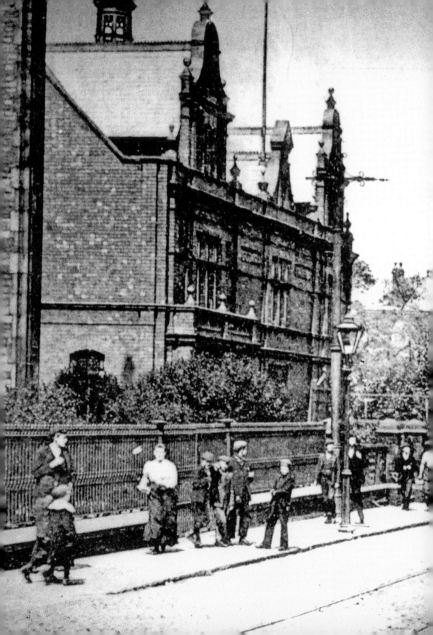

24. ST PETERSGATE

This horse-drawn tram is leaving St Petersgate to turn onto Wellington Road South. The chain horse has been added to help the tram up the steep slope. This was a common sight in Stockport as there were many steep roads leading out from the Mersey Valley. As the tram climbed up past the Town Hall it would pass over wooden sets, which were intended to prevent a clatter from disturbing the patients in the infirmary opposite.

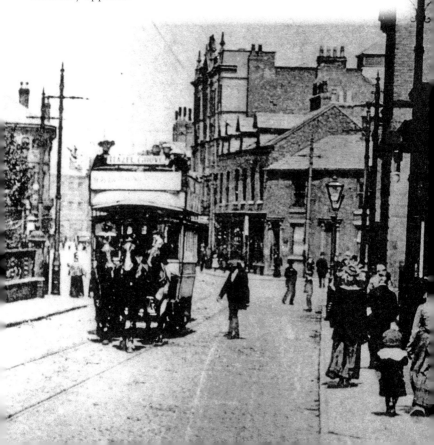

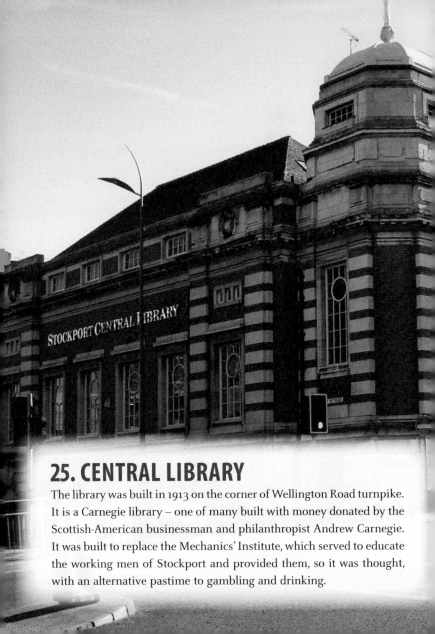

25. CENTRAL LIBRARY

The library was built in 1913 on the corner of Wellington Road turnpike. It is a Carnegie library – one of many built with money donated by the Scottish-American businessman and philanthropist Andrew Carnegie. It was built to replace the Mechanics' Institute, which served to educate the working men of Stockport and provided them, so it was thought, with an alternative pastime to gambling and drinking.

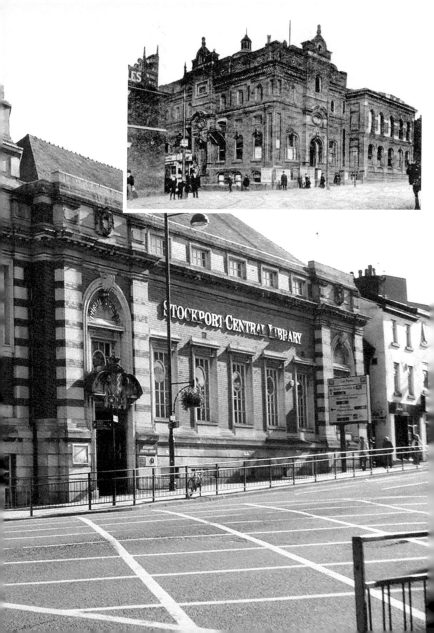

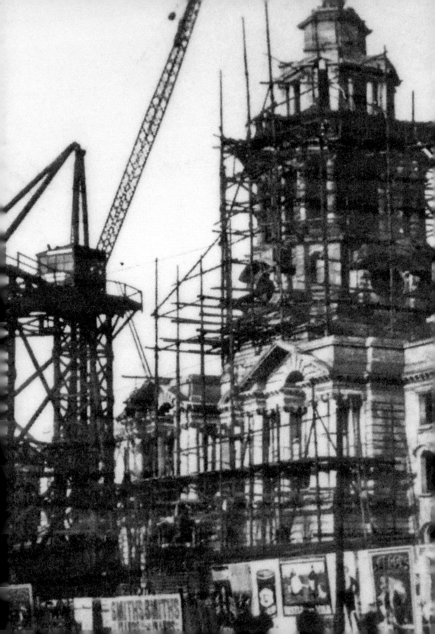

26. TOWN HALL

This photograph shows the construction of Stockport's first purpose-built Town Hall. Designed by the architect Sir Alfred Brumwell Thomas, who had previously designed Belfast City Hall, it was opened by the then Prince and Princess of Wales, later to be George V and Queen Mary. The imposing Italian marble entrance and staircase leads to the Edwardian ballroom, which former Poet Laureate Sir John Betjeman described as 'magnificent'.

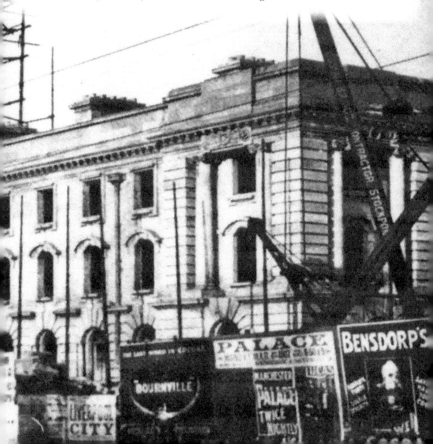

27. MOUNT TABOR CHAPEL

Mount Taber Chapel was a huge Methodist church on the corner of Edward Street and Wellington Road South. It could seat 900 people and had thirty-eight teachers for the Sunday school. After it was demolished, the capitals that once graced the top of its columns were saved and used to decorate a small paved seating area. It now contains the statue of James Conway, one of the 'Cockleshell Heroes' shot during the Second World War.

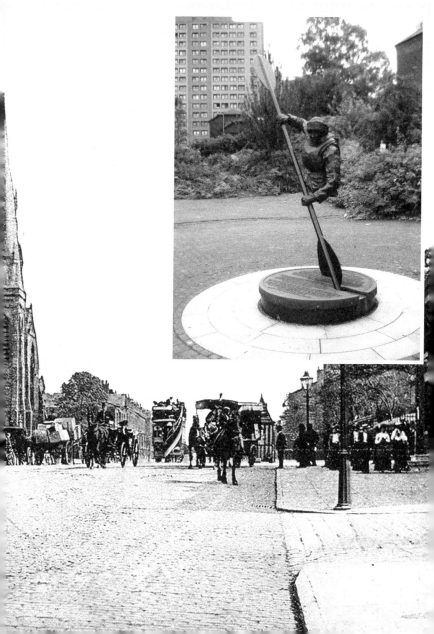

28. ART GALLERY

The art gallery is also Stockport's war memorial, with a hall of memory containing a sculpture and commemorative tablets that record the names of 2,200 men of Stockport who lost their lives during the First World War. The land was given to the town by Mr Samuel Kay JP, who lost his only son in the conflict. The building cost £24,000 and was paid for by voluntary subscriptions from the people of Stockport.

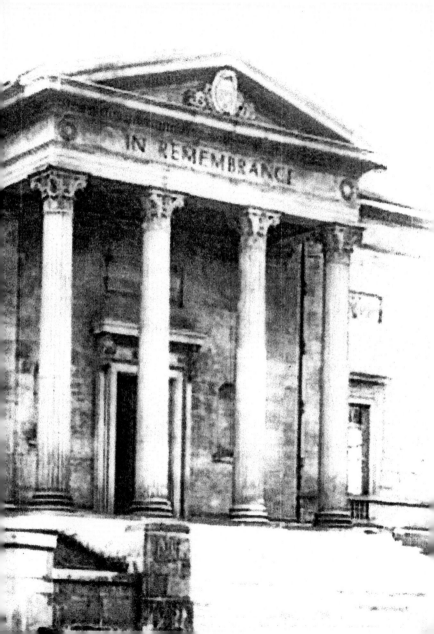

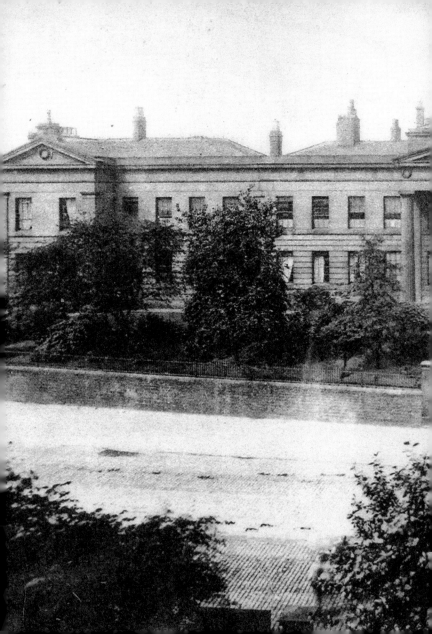

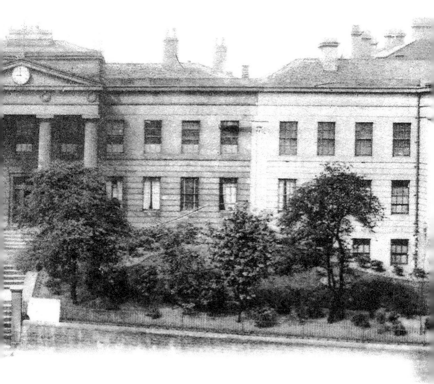

29. STOCKPORT INFIRMARY

The infirmary was built using donations from the people of Stockport when the dispensary on Baw Bank was not adequate for the expanding town. While recruiting for the First World War undernourished and overworked millhands were sent to be 'built up', ready to be sent to the trenches. The infirmary was always supported by the annual carnival until it was handed over to the National Health Service in 1948.

30. WELLINGTON ROAD

This road was Stockport's bypass, which was built through open fields and opened with great pomp in 1826. Only eleven years after Wellington's great victory at Waterloo, it was decided to name it after him. The arches seen on the photograph are hollow inside and could be used for storing coaches and stables for the nearby Wellington Inn. It was not unusual in those days to drive livestock to market through the town.

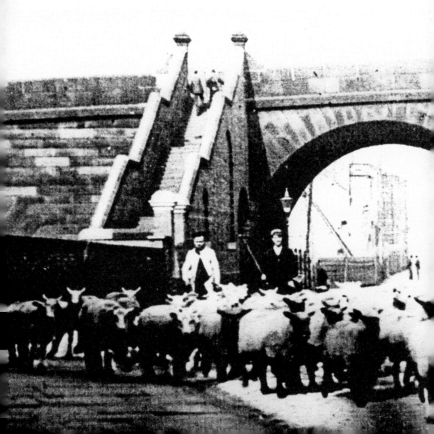

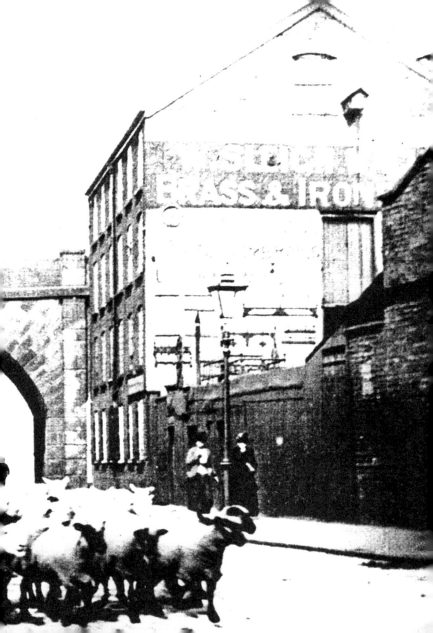

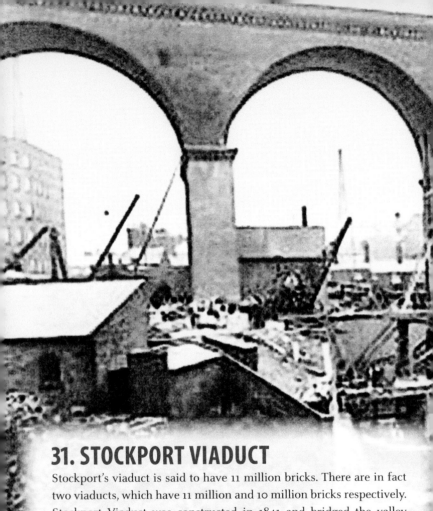

31. STOCKPORT VIADUCT

Stockport's viaduct is said to have 11 million bricks. There are in fact two viaducts, which have 11 million and 10 million bricks respectively. Stockport Viaduct was constructed in 1841 and bridged the valley from Stockport station to Heaton Norris, but there were only two tracks and it soon became obvious that it was not going to be wide enough. A second structure was then added. To do this part of Weir Mill had to be taken down and rebuilt afterwards.

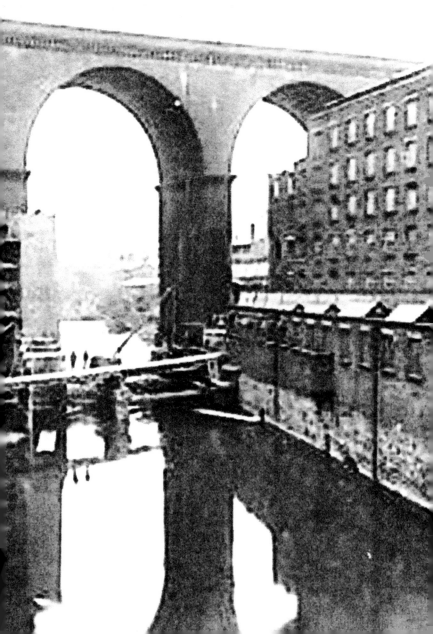

32. PRINCE'S STREET

Once known as Heaton Lane, this road was on the Lancashire side of
the river. Each side of Stockport had its own shopping street, divided
by the River Mersey. When the Prince and Princess of Wales came by
train to Stockport to open the new Town Hall they were driven down
Heaton Lane and, as they passed, new name plates fell into place,
renaming it Prince's Street in his honour.

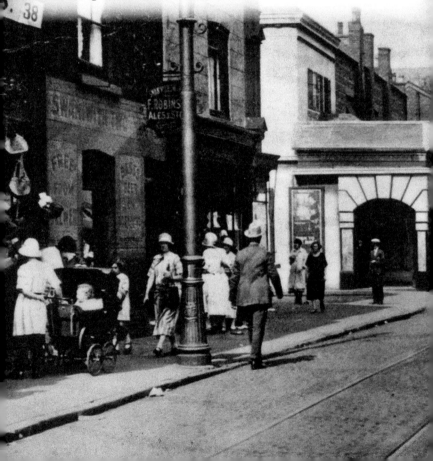

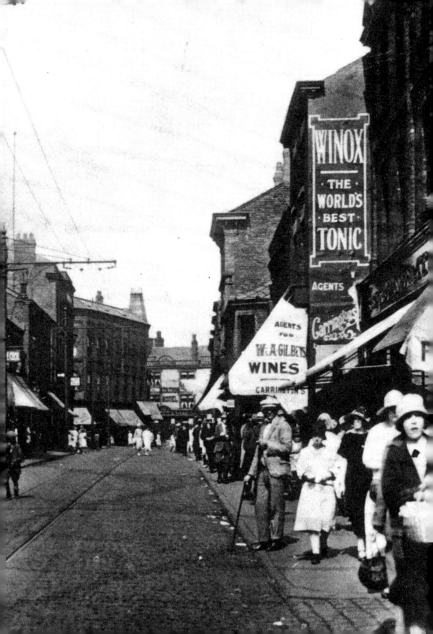

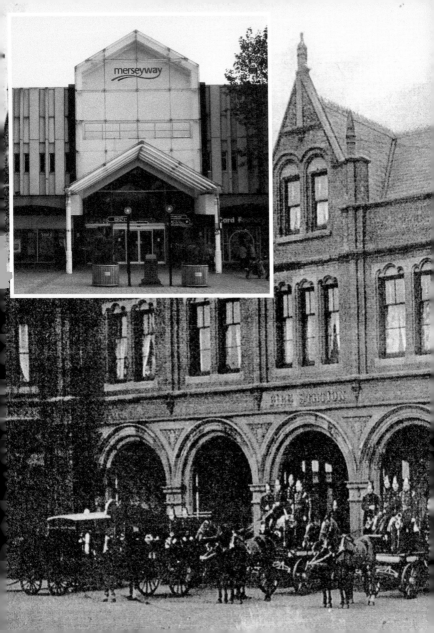

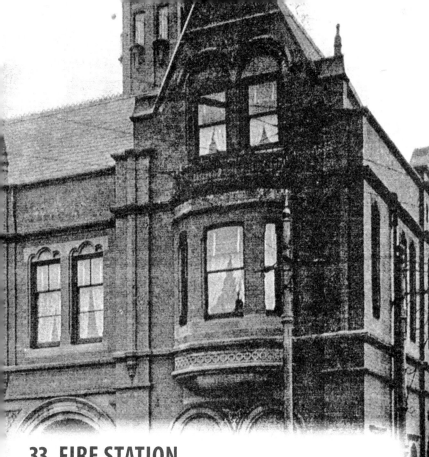

33. FIRE STATION

Stockport's fire station was a grand building. It had five arches to allow quick access to Wellington Road for the appliances. One day tragedy struck in the early hours of the morning as the fire engine *Mary Dalzil* rounded the bend onto Wellington Bridge and overturned, smashing down 20 feet onto the road below. Superintendent Howard Beckwith was fatally injured and the town went into mourning. A huge number turned out for his funeral procession.

34. MERSEY BRIDGE

Stockport was always a town divided and Mersey Bridge was another attempt to join the two halves. It connected Prince's Street on the Lancashire side to Chestergate on the Cheshire side of the river and made a huge difference to the town. It became a hub for trams criss-crossing the town in all directions. Later a tram station was built next to the fire station.

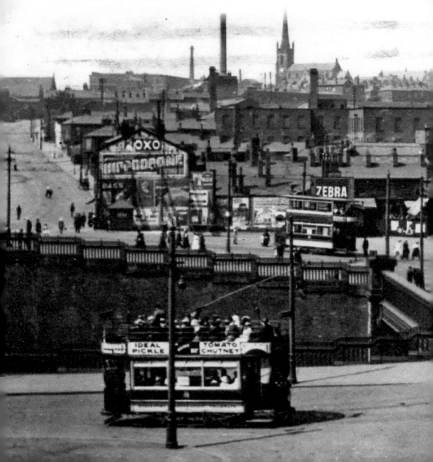

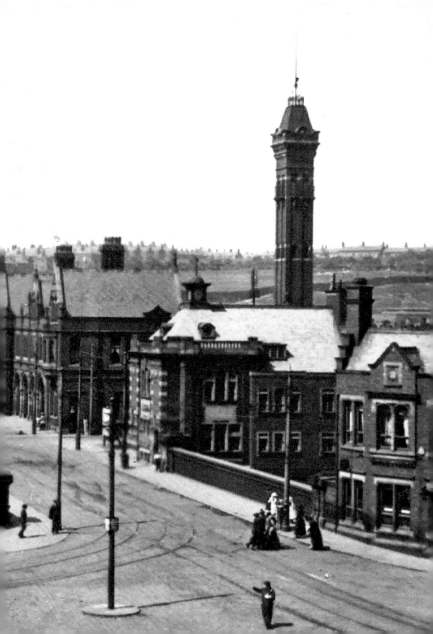

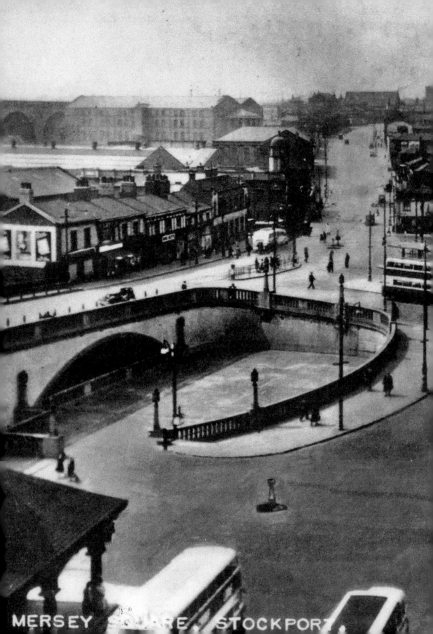

MERSEY SQUARE, STOCKPORT.

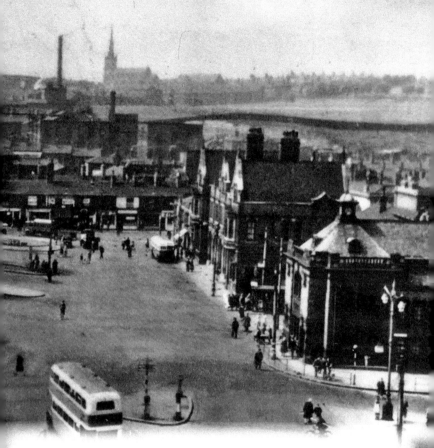

35. BEAR PIT

'Bear Pit' is a nickname given to an area of paving that covers the river. In the 1930s the iron bridge was taken away and the whole area covered to make Mersey Square, but the sunken area linked two levels of road and formed a place remembered by the children of the 1950s as where the Christmas tree stood with presents underneath for orphans. It's now a seating area for those wishing to rest and reflect.

36. PLAZA

Stockport's art deco theatre was nearly lost forever, until a group of enthusiastic volunteers put together a programme to save and use this amazing survivor. The cottages that were there before housed a public house, which had the longest name in Britain: The Seven Alls – I Govern All, I Pray For All, I Judge All, I Plead For All, I Provide For All, I Work For All and I Fight For All.

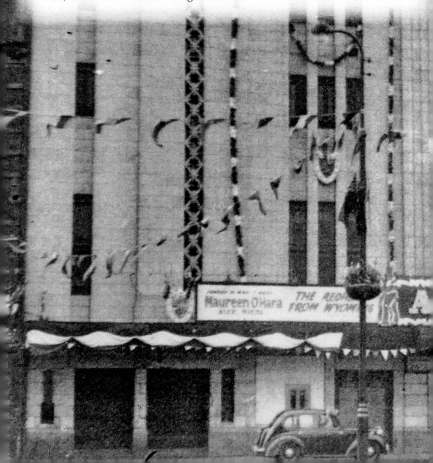

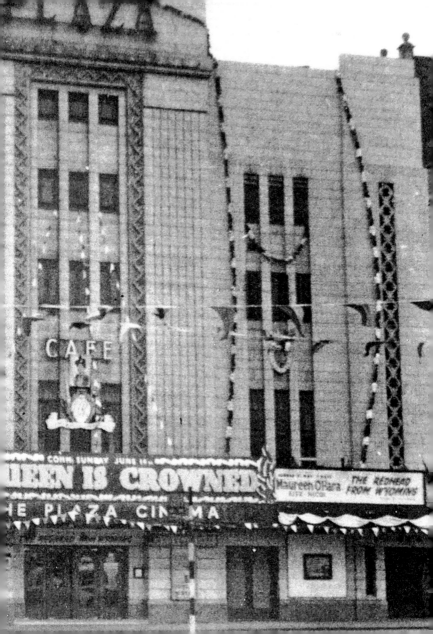

CAFE

EEN IS CROWNED

Maureen O'Hara
THE REDHEAD
FROM WYOMING

HE PLAZA CINEMA

37. PETTY CARR GREEN

The area sandwiched between the River Mersey and where the plaza now stands was once called Petty Carr Green. It was an open space and was ideal for an annual fair to visit the town. These Edwardian girls in their large hats and white pinafores seem to be looking at the merry-go-round with interest and anticipation.

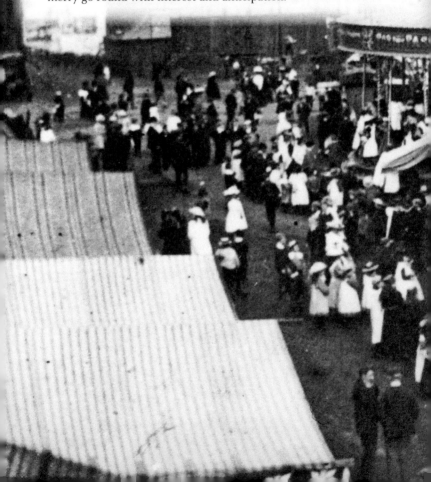

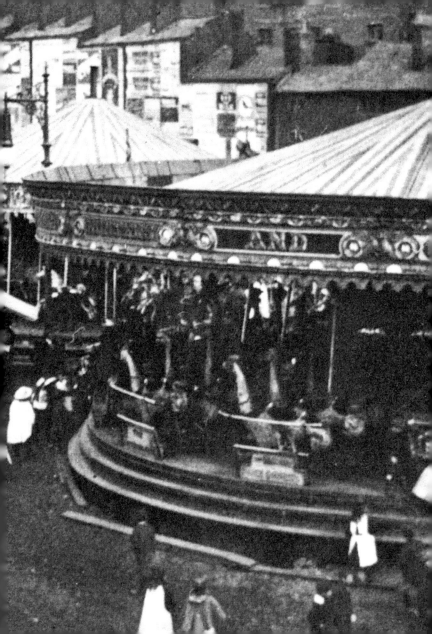

38. ROCK ROW

Rock Row, leading up to St Peter's Square, housed a row of four-storey houses. The bottom two floors were accessed from the road and the higher two from the square above. During the riots of 1852 the houses were occupied by Irish workers, who were attacked by their neighbours for taking their jobs. Bricks and stones were thrown over the houses and people fled in terror. They were replaced by a warehouse.

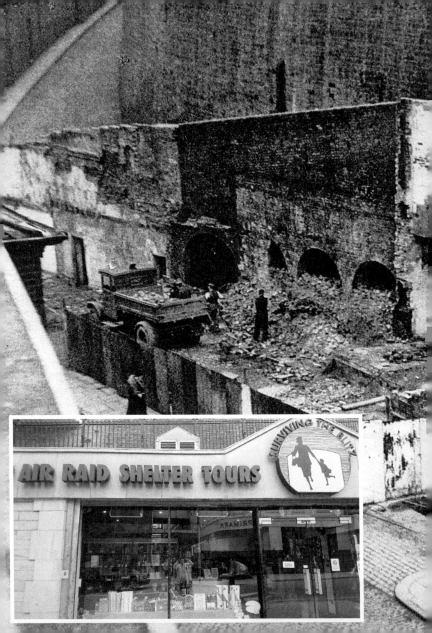

39. AIR-RAID SHELTERS

In the late 1930s houses on Chestergate were demolished for road widening. Behind them rooms were dug into the rock face by residents to enlarge their homes. It gave the borough engineer the idea of digging into the rock to create air-raid shelters. Intended for air raids during the day when people were at work, they ended up as night-time protection for coachloads from Manchester. They christened it the Chestergate Hotel.

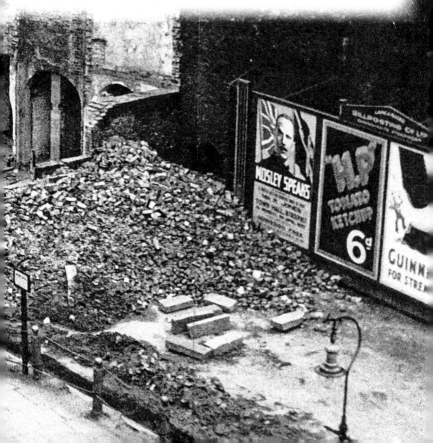

40. GREAT UNDERBANK FLOODS

This area of the town is where the Tin Brook passes under Chestergate. It is now culverted but used to be an open stream with a small bridge. The photograph shows one of the many times when the culvert has blocked and caused flooding. Back in medieval times it was reported that a flood was so great that it covered the parapets of the bridge, making it impassable.

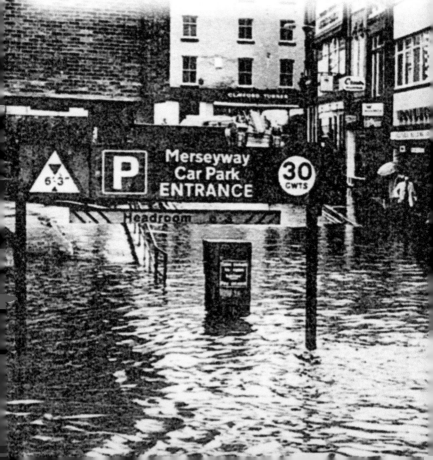

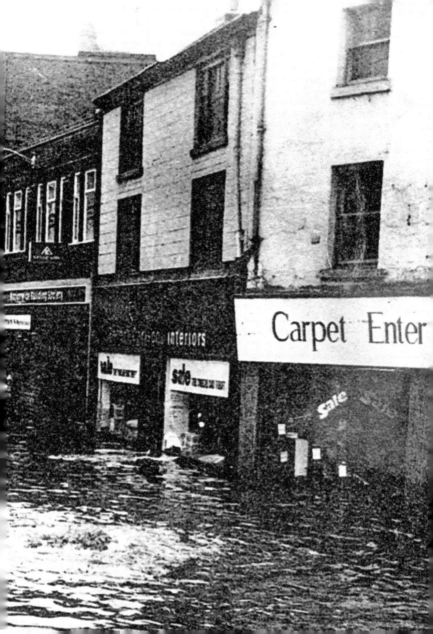

41. THREE SHIRES

This timber-framed building was the sixteenth-century town house for the Leghs of Adlington. Most of the gentry had homes in town for when on business, but they were mainly sold around 1830 and this has been a café/wine bar for a hundred years. In Edwardian times it was called Fowden's and the genteel ladies of the town would call for sherry and cake in the afternoons.

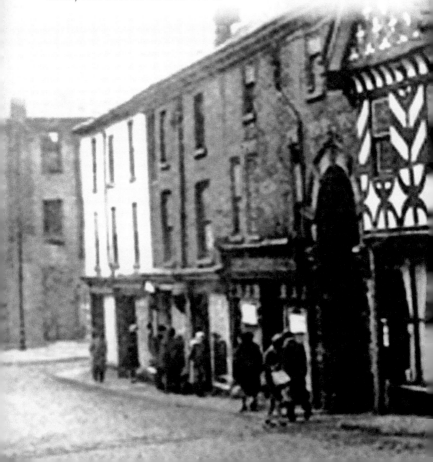

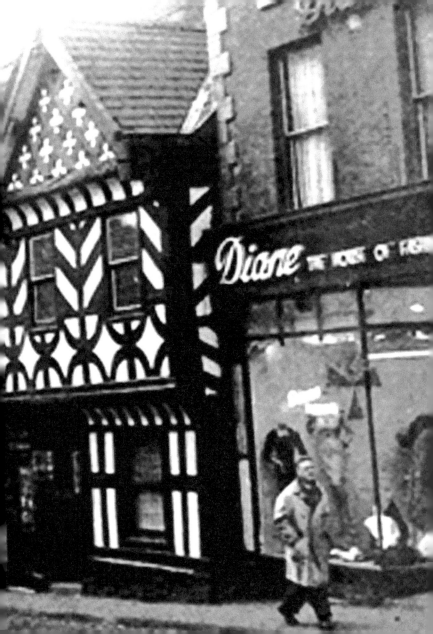

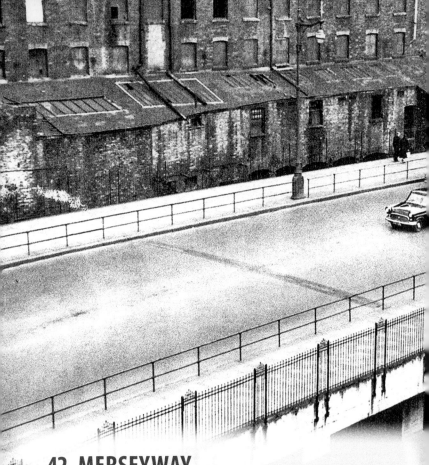

42. MERSEYWAY

Merseyway was the road first built to cover over the River Mersey back in the 1940s. It was constructed with a series of arches and is therefore a bridge and not a culvert, making it probably the widest bridge in the country. Stockport Heritage Trust took the time to measure it and it measures 435.7 metres from Lancashire Bridge in the east to the Bear Pit in the west.

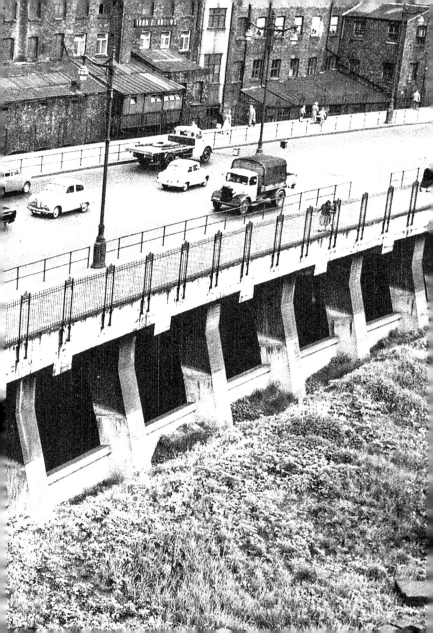

43. MERSEYWAY PRECINCT

The Merseyway road was not the success it was intended to be as traffic preferred to use an alternative east to west route. In the late 1950s it was decided to change it into a shopping precinct. The shops were built either side of the road, except at the Mersey Square end, and the road became a pedestrian route. The different contours of the town were utilised, allowing two levels of shops with parking above – a clever design.

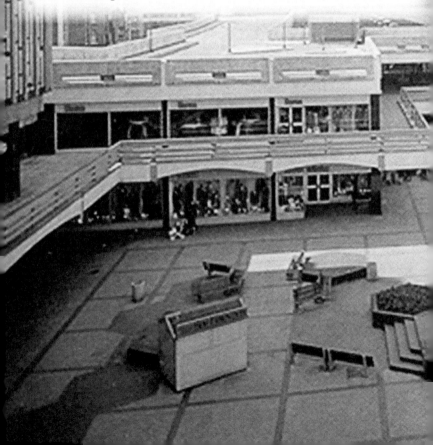

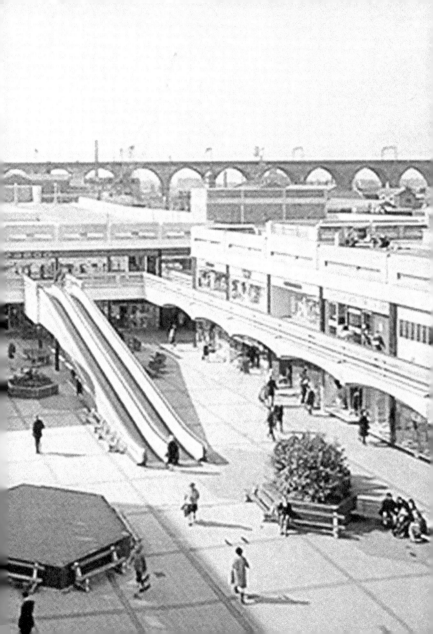

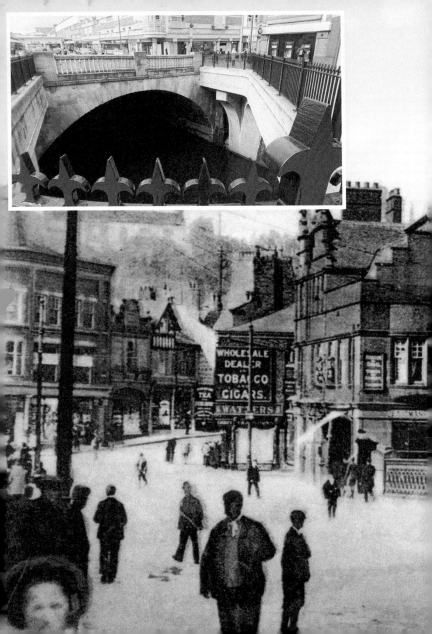

44. LANCASHIRE BRIDGE

Known as Stockport Bridge, it was built in the late thirteenth century to join Lancashire and Cheshire, allowing access to Stockport Market for people who did not want to get their feet wet while fording the River Mersey. It has been a strategic bridge many times when the country was in conflict, and was taken down when Bonnie Prince Charlie was heading south to take London with a Scottish army. It was recently opened to view.

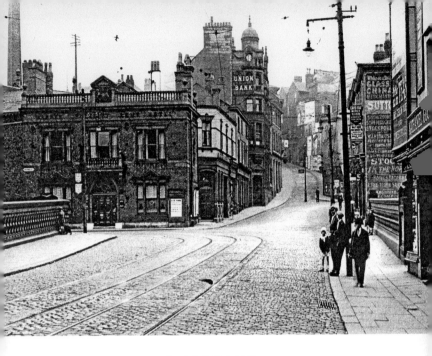

45. WARREN BULKELEY

With a new function room for the council, it was here that the Stockport Arctic explorer Admiral Sir George Back was entertained following one of his expeditions. Another group to use it were the local yeomanry, who were at odds with the working men due to strikes, riots and many disturbances where they clashed. It is said that they took their revenge by heating up pennies and throwing them to the starving children.

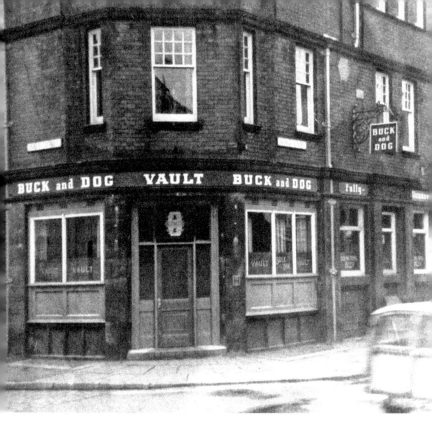

46. THE BUCK AND DOG

The Buck and Dog was a public house on the Lancashire side of the river. Following the flood of 1799, James Brown, the pub landlord, erected a plaque on the side of his building to indicate the level of the floodwater. It is now positioned behind Barclays bank and is no longer close to the place or level of the flooded river.

ACKNOWLEDGMENTS

I would like to thank the Stockport Heritage Trust for the use of their photograph collection and research material. Thanks also go to Stockport Heritage Library.

ABOUT THE AUTHOR

I first became interested in local history through collecting old bottles. Each had Stockport and the name of the pub, chemist or mineral manufacturer embossed on the outside. I wanted to know more about these objects: how old they were, where the premises stood and a little about the people involved with them.

My research then led me to write an article for the local heritage magazine, which to my amazement was published. Research and writing then became a regular pastime and over the next twenty years I wrote many articles about various topics for the magazine.

In 2003 I joined the Stockport Heritage Trust and have been involved in many events, exhibitions and projects with my colleagues. I've recently stepped down as secretary after fourteen years, but still lend a hand in our heritage centre, which is based in St Mary's Church in the Market Place.

Over the years I've written a number of books for the Heritage Trust, Amberley and some published privately: *Marple Through Time* (co-author), *Stockport Through Time*, *Rivers Under Your Feet*, *Inns & Outs of Stockport Taverns*, *Stockport Past and Present* and *Pigs, Peasants & Pestilence*.